MW00817972

THIS SKETCHBOOK
BELONGS TO

ONE COLOR A DAY

A DAILY ART PRACTICE
AND
VISUAL DIARY

COURTNEY CERRUTI

ABRAMS NOTERIE, NEW YORK

This sketchbook is dedicated to anyone who wants to find more time for creativity, to practice mindfulness, to experiment with watercolor, and to capture one year in a unique way.

XO
Courtney

HOW I BEGAN

It is hard—for everyone—to find time for reflection and creativity. When we do have the time, the pressure of being creative feels overwhelming. As an artist and someone whose profession is in the craft world, people recognize me as a generally artistic, creative, and productive person, and yet I have still struggled to faithfully maintain a sketchbook.

Until I set myself up for success. I grabbed a watercolor journal, divided each page into boxes, and penciled in the dates for the next twelve months. I wanted something I could do daily without the perfect studio space or a lot of time, using a limited amount of materials. Something I could do on days when I felt my least creative.

By prepping my sketchbook and having a clear goal, a color and a line a day, I was ready to take on the year starting a new creative practice: One Color a Day.

After a few weeks, an initial spark of novelty shifted into a *desire* to end my day with this practice. I couldn't go to sleep if I hadn't done it. This is the shift that is most meaningful. In creating a practice, whatever it is, you need to establish a habit. Just like brushing my teeth every night before bed, recording a color and phrase became a necessity in my nightly routine.

YOUR REASONS FOR STARTING

Everyone has a different entry point for beginning a daily practice. It helps to identify what is personally motivating for you. Here are a few compelling reasons to start painting one color a day. Think about which one speaks to you the most.

It's a pressure-free way to start a habit or ritual.

If you find it challenging to maintain consistency when it comes to being creative, working in a sketchbook that is expressly set up for a single purpose makes it easy for you to dive in and see results right away: a beautiful row of colors representing your days! It will give you confidence in the idea that small, daily gestures really do add up. Stick with it for a few weeks until it becomes a habit you can't quit.

All it takes is five minutes.

If time is your biggest challenge, this practice can take as little as a few moments out of your day. You can do it while you are having your morning coffee, or you might keep your sketchbook and paint palette in one spot in the kitchen and record your color after a meal. You don't need to be precious about it or agonize over it. Just paint a color and jot down a name underneath it. That's it.

 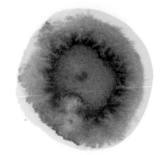 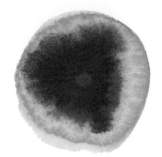

It is a highly personal way to capture your days.

Despite our best intentions to slow down, remember, and appreciate certain moments, life moves very fast. You can use your color-a-day exercise to capture a quiet lunch break when you heard bees buzzing in the flowers, or a stimulating conversation with a friend over coffee. Just putting down one color to represent your favorite part of the day, or to symbolize your current mood, is an effortless way to record what is often fleeting and forgotten.

THE
SETUP

This sketchbook is designed specifically for your daily practice. There are spaces for painting one color a day for fifty-two weeks (one full year). Here's how I envision using this grid, but you can certainly adapt it to your own preferences.

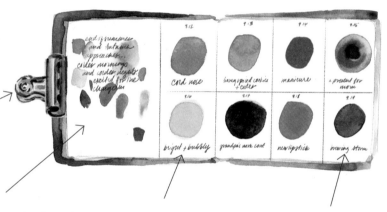

Use a binder clip to keep your book open while you are working and when your paint is drying.

If a line a day isn't enough to record your thoughts, use the extra room for additional reflections that week. You can also test colors here.

Jot down the date at the top of these sections, paint your color, and write a word or phrase that you associate with the color underneath.

This bonus space could be used for painting one color to represent your entire week, or you could use it for additional test swatches and writing.

COLOR
NAMING

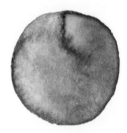

afternoon naps

The way that you choose and name your colors will evolve with your experiences and emotions. You might paint a color that reminds you of an object or place you saw. Label your colors with a single noun like *home*, or perhaps a phrase like *bird's wing* or *fresh snow*. Some days may call for more description, like *milk swirling in coffee* or *fresh buds in spring*. You might pull out a line from a song on the radio or a few words overheard on the street. Other days feel like action days. Perhaps *run*, *play*, or *sing* might best describe your color.

If you need additional structure or motivation, think about approaching your week with a theme. You could choose colors that remind you of important people in your life or dedicate the week to things that you are grateful for. Throughout the sketchbook, you'll encounter pages where I've tested out different themes. Use your one-color-a-day practice as an opportunity to focus on moments that really matter to you. This is the essence of mindfulness.

MATERIALS

Since you'll be painting every day, I'd highly recommend getting a good-quality travel watercolor set. Ideally, find a space where you can leave out your paints, a brush, a pencil, a cloth, a cup for water, and your sketchbook. If this isn't feasible, keep these materials together in a box or tote bag so that you can pull them out quickly or take them anywhere. Perhaps you'll want to change the location of your practice. Maybe the setup will become part of your ritual.

I love watercolor because you can mix colors for innumerable shades, and the medium always has the upper hand, leaving you a bit surprised and delighted in the end. Of course, you can use other mediums if you prefer: colored pencil, brush marker, or perhaps even collage.

Travel Watercolor Set

Look for a set that has a fold-out palette for mixing and a warm and cool version of each of the primary colors (yellow, red, and blue). I also like to have a few neutrals, such as ochre, burnt sienna, and sepia. Most sets will include one or two greens, but I prefer to mix my own. Instead of using black, I mix my darkest neutral (usually sepia) and a dark blue. My own palette would never be complete without indigo and hot pink (Opera Rose), so I buy them as separate tubes.

Paintbrush and Pencil

A size 6 or 8 round brush will make a thick mark when pressed fully or a thin line when using little pressure on the pointed end. This size is ideal for mixing colors or dropping, swirling, and manipulating colors to create painterly effects in your dot. For writing, I'm a big fan of the Paper Mate mechanical pencils.

Container and Towel

You will need a cup for water and a cloth to blot your brush and clean it thoroughly before switching colors.

COLOR WHEEL

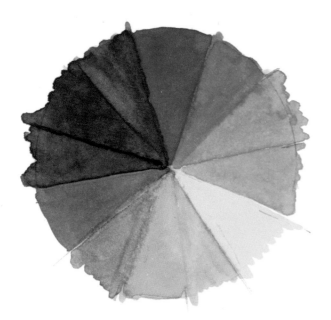

Primary colors include red, yellow, and blue. These colors are mixed to create secondary colors.

Secondary colors include orange (red + yellow), purple (red + blue), and green (yellow + blue).

Complementary colors are opposite each other on the color wheel. They are red and green, yellow and purple, and orange and blue. When used together unmixed, these color pairs are especially dynamic and eye pleasing.

Neutral colors can be made by mixing complementary colors together. Two complementary colors can make beautiful browns, plums, and grays, but can also result in muddy tones if you overmix them.

All of the hues that you find on the color wheel are mixes of the primary colors in various combinations. The exception to this is vibrant neon or fluorescent colors. I always supplement my palette with Opera Rose so I have a nice hot pink on hand.

COLOR MIXING TECHNIQUES

Mixing on a Palette

Wet your brush with clean water. Pick up a little color and paint onto your palette. Clean your brush, pick up a new color, and add it to the first one on your palette. Mix the colors with your brush until you make a single solid color that you really like, and then paint a circle in your sketchbook using this mixed pigment.

Dropping in a Color

Start by painting a circle on your sketchbook page with clean water. Then load your brush with pigment and gently dab it into the center of the wet circle. Allow the color to spread to the edge of the wet circle. Depending on the pigment and your brush handling, you might get some interesting dense color in the center and little fingers of color radiating to the edge of circle.

Dropping in Multiple Colors

Again, start by painting a circle on your sketchbook page with clean water. Pick up a little of one color and touch the wet circle with the tip of your brush. Clean your brush and then add another color. Try putting three or four colors in the circle. Avoid mixing the colors with your brush and allow colors to interact organically in the pool of water on the page.

Mixing Color on the Page

Repeat the steps for dropping in multiple colors, but this time use your brush to push the pigments around in the circle. See what happens when you intentionally move one color into another. You'll likely end up with a mostly solid color that has visible traces of the original two colors that you mixed.

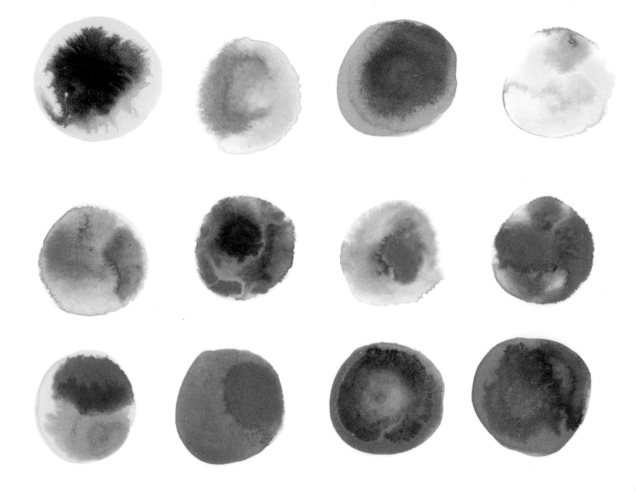

EXPERIMENTING WITH MULTIPLE COLORS

Yes, the purpose of this sketchbook is to paint just one color a day, but who's to stop you from experimenting? Working with multiple colors in a single circle can result in unexpected and eye-popping results. The key here is to let the paint do its thing. Each pigment has its own saturation and density and will travel in its own unique way.

To create the circles on the opposite page, I placed pigment in the center of a clear dot of water (resulting in a more irregular outer edge) or painted a solid color to create a base circle. I then cleaned the brush, picked up a new color, and dropped it in the center of the circle. Sometimes you'll see rivulets of colors or thick irregular bands. If a color doesn't do much, I add a little more of the same pigment or water to the brush and try again. Most of these circles were created with three or four colors. In the circles where the same pigments were used, but in a different order, the results varied dramatically.

WEEK 1

___ / ___ / ___

___ / ___ / ___

___ / ___ / ___

___ / ___ / ___

___ / ___ / ___

EXTRA

WEEK 2

___ /___ /___

___ /___ /___

___ / ___ / ___

___ / ___ / ___

___ / ___ / ___

___ / ___ / ___

___ / ___ / ___

EXTRA

WEEK 3

___ /___ /___

___ /___ /___

___ / ___ / ___

___ / ___ / ___

___ / ___ / ___

___ / ___ / ___

___ / ___ / ___

EXTRA

WEEK 4

___ /___ /___

___ /___ /___

___ / ___ / ___

___ / ___ / ___

___ / ___ / ___

___ / ___ / ___

___ / ___ / ___

EXTRA

A WEEK OF NATURE

Early in your color-a-day practice, you may find it easiest to pick a daily color from the environment around you. Nature offers unlimited color inspiration, and slowing down to observe it gives you an opportunity to feel more connected to your surroundings. If you live in a place with distinct seasons, return to this exercise a few times a year, and allow the current colors to guide your palette that week. You might decide to focus on a single aspect of nature, such as a color representing the weather each day. Or you could go a step more abstract and pick a color that signifies how the weather makes you feel.

the underside of leaves

sulfur, lichen, poisonous frogs

ladybug
shell

I only like
purple in nature

Streaks in
black sand

mountain
range

a touch of
Autumn

the deepest
parts

WEEK 5

___/___/___

___/___/___

___/___/___

___/___/___

___/___/___

EXTRA

WEEK 6

___ /___ /___

___ /___ /___

___ / ___ / ___

___ / ___ / ___

___ / ___ / ___

___ / ___ / ___

___ / ___ / ___

EXTRA

WEEK 7

____ / ____ / ____

____ / ____ / ____

____ / ____ / ____

____ / ____ / ____

____ / ____ / ____

EXTRA

WEEK 8

___ / ___ / ___

___ / ___ / ___

___ /___ /___

___ /___ /___

___ /___ /___

___ /___ /___

___ /___ /___

EXTRA

A WEEK OF GRATITUDE

Consider the things for which you are grateful. These can be tiny daily occurrences, people or places in your life, or rituals you find rewarding. Nothing is too small or too big. Tangible things, like your morning cup of coffee or your most comfortable pajamas, are probably fairly easy to translate into a color. If you are trying to capture something invisible (a compliment that you received or a supportive conversation with a friend), try choosing the color intuitively. Don't worry about getting it "right." The important thing is to simply recognize and honor these moments by recording them.

morning cuddles
with Charlie

afternoon
naps

a full glass of
ice tea

rambling voice mails
from my mom

no traffic

morning
smoothie

ever-changing
green eyes

finding Charlie
in a pile of fresh
laundry

WEEK 9

___ / ___ / ___

___ / ___ / ___

___ / ___ / ___

___ / ___ / ___

___ / ___ / ___

___ / ___ / ___

___ / ___ / ___

EXTRA

___ /___ /___

___ /___ /___

___ / ___ / ___

___ / ___ / ___

___ / ___ / ___

___ / ___ / ___

___ / ___ / ___

EXTRA

____ /____ /____

____ /____ /____

___ / ___ / ___

___ / ___ / ___

___ / ___ / ___

___ / ___ / ___

___ / ___ / ___

EXTRA

___ /___ /___

___ /___ /___

___ / ___ / ___

___ / ___ / ___

___ / ___ / ___

___ / ___ / ___

___ / ___ / ___

EXTRA

A WEEK OF ONE SUBJECT

Select one thing to focus on this week. There are so many facets to the people, things, and places in our lives, so why not pick a color for each quality? I chose my sidekick and pup, Charlie. I adore the way his little tongue sticks out, his dark, trusting eyes, and his warm pink belly. At the end of the week, the color selection that I arrived at by observing Charlie looks happy and cozy to me; I might pick up this palette for another project that calls for this mood. Of course, you don't have to focus exclusively on the positive traits of your subject. This is a week for noticing contradictions and complexity.

tiny nose

caramel-colored patches

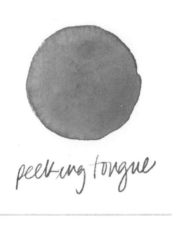

peeking tongue

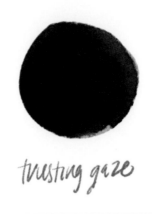

trusting gaze

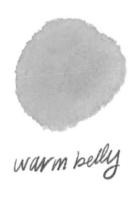

warm belly

favorite toy

dusty paw pads

errant kiss mark

WEEK 13

___ /___ /___

___ /___ /___

___ / ___ / ___

___ / ___ / ___

___ / ___ / ___

___ / ___ / ___

___ / ___ / ___

EXTRA

WEEK 14

___/___/___

___/___/___

___/___/___

___/___/___

___/___/___

EXTRA

WEEK 15

___ / ___ / ___

___ / ___ / ___

___ / ___ / ___

___ / ___ / ___

___ / ___ / ___

EXTRA

___ /___ /___

___ /___ /___

___ / ___ / ___

___ / ___ / ___

___ / ___ / ___

___ / ___ / ___

___ / ___ / ___

EXTRA

A WEEK OF EMOTIONS

Tracking your daily mood with color is going to be easier some days than others. If you cycle through several emotions in one day, you might be unsure about which one to capture on the page. You may not have a particularly strong or identifiable emotion when it comes time to paint. Sit with this exercise for a minute and see what surfaces. Use this practice as a way to record whatever it is that you're feeling, without judgment. Over time, you may notice recurring emotional patterns. On the flip side, you might begin your day by painting a color representing the outlook that you intend to bring to your day.

awaiting her arrival

gliding along

blinding joy

rivulets of
apprehension

the approaching
season

safety

blooming
interest

finding joy in
the details

___ /___ /___

___ /___ /___

___ / ___ / ___

___ / ___ / ___

___ / ___ / ___

___ / ___ / ___

___ / ___ / ___

EXTRA

___ /___ /___

___ /___ /___

___ / ___ / ___

___ / ___ / ___

___ / ___ / ___

___ / ___ / ___

___ / ___ / ___

EXTRA

___ /___ /___

___ /___ /___

___ / ___ / ___

___ / ___ / ___

___ / ___ / ___

___ / ___ / ___

___ / ___ / ___

EXTRA

WEEK 20

___ /___ /___

___ /___ /___

___/___/___

___/___/___

___/___/___

___/___/___

___/___/___

EXTRA

A WEEK OF MEMORIES

The color-a-day practice is an obvious way to
capture your current moment, but there's nothing
to stop you from drawing on past experiences. You
can use this exercise to revisit favorite memories
from a recent vacation, or you might time travel
back to your childhood. Choose an indelible color
from the past, like the exact tint of the key lime
pie that your grandmother used to make. Or you
can pick a color that represents a feeling (home
for the holidays) or a scent (opening the cedar
toy chest). When experimenting with this theme,
I remembered many moments from childhood
that both surprised and delighted me. I ended up
with a page that represents a totally unique mix of
feelings, sensations, and tangible objects.

picking
tomatoes

cool + smooth
to the touch

childhood
teddy

a gift of peridot
earrings

bright, tart
lipsmacking

the quilt in
the york st apt.

cozy +
warm

collecting

___ / ___ / ___

___ / ___ / ___

___ / ___ / ___

___ / ___ / ___

___ / ___ / ___

___ / ___ / ___

___ / ___ / ___

EXTRA

WEEK 22

___ / ___ / ___

___ / ___ / ___

___ / ___ / ___

___ / ___ / ___

___ / ___ / ___

___ / ___ / ___

___ / ___ / ___

EXTRA

___ /___ /___

___ /___ /___

___ / ___ / ___

___ / ___ / ___

___ / ___ / ___

___ / ___ / ___

___ / ___ / ___

EXTRA

___ / ___ / ___

___ / ___ / ___

___ / ___ / ___

___ / ___ / ___

___ / ___ / ___

___ / ___ / ___

___ / ___ / ___

EXTRA

A WEEK OF MANIFESTING

The future is so full of possibilities, wonder, and
even fear. This week, name the things you want
for your future. The future can be as soon as
tomorrow or as far as a decade from now. This
exercise is similar to creating a vision board,
except that you are using colors and words
instead of images. Your colors can represent
states of mind you want to cultivate (like patience
or optimism), skills that you're developing, places
you'd like to see, and opportunities that you hope
will materialize. Don't be afraid to put your
desires on paper!

afternoon naps

letting go

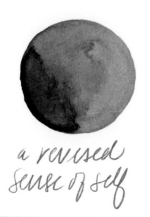

a revised
sense of self

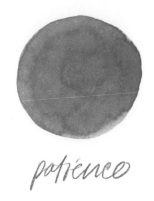

patience

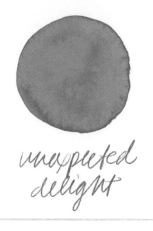

unexpected
delight

purpose

trust in
the unknown

satisfaction

___ /___ /___

___ /___ /___

___ / ___ / ___

___ / ___ / ___

___ / ___ / ___

___ / ___ / ___

___ / ___ / ___

EXTRA

WEEK 26

___ /___ /___

___ /___ /___

___ / ___ / ___

___ / ___ / ___

___ / ___ / ___

___ / ___ / ___

___ / ___ / ___

EXTRA

___ /___ /___

___ /___ /___

___ / ___ / ___

___ / ___ / ___

___ / ___ / ___

___ / ___ / ___

___ / ___ / ___

EXTRA

___ / ___ / ___

___ / ___ / ___

___ / ___ / ___

___ / ___ / ___

___ / ___ / ___

___ / ___ / ___

___ / ___ / ___

EXTRA

A WEEK OF PEOPLE

Spend a few moments this week thinking about the significant people in your life. You could include someone you see daily, someone who's passed, or a childhood friend whom you haven't seen for years. Or maybe fill in this week with people you haven't met personally, but are important to you nonetheless: your heroes, favorite characters from books or movies, and inspiring historical figures. Choosing a distinct color for each person gives you a chance to think about their unique impact or influence on you. Share your daily color with these folks, if you can.

jojo

mom

kiki

nana

mama

dad

faith

Alicia

___ / ___ / ___

___ / ___ / ___

___ / ___ / ___

___ / ___ / ___

___ / ___ / ___

___ / ___ / ___

___ / ___ / ___

EXTRA

___ /___ /___

___ /___ /___

___ / ___ / ___

___ / ___ / ___

___ / ___ / ___

___ / ___ / ___

___ / ___ / ___

EXTRA

___ /___ /___

___ /___ /___

___ / ___ / ___

___ / ___ / ___

___ / ___ / ___

___ / ___ / ___

___ / ___ / ___

EXTRA

WEEK 32

___ /___ /___

___ /___ /___

___ / ___ / ___

___ / ___ / ___

___ / ___ / ___

___ / ___ / ___

___ / ___ / ___

EXTRA

A WEEK OF SENSATIONS

Instead of painting and naming colors or things your see, tap into your other senses. Think of things you touched, tasted, or heard and let them guide your painting practice. This is a particularly good exercise to try when you are on vacation or in an unfamiliar place where your senses are heightened. Engaging your five senses has proven to have a calming effect. If you are feeling anxious, take a moment to notice a scent, a texture, and a sound in your environment, and pick a color to represent your observations. You'll feel more grounded at the end of this creative interlude.

gliding through water

freshness...
fresh melon
fresh mint
fresh air

the scent of
wild sage

a memory
just out of reach

a bright and fleeting
sweetness

Sticky residue

a steady
warming

velvety
softness

___ /___ /___

___ /___ /___

___ / ___ / ___

___ / ___ / ___

___ / ___ / ___

___ / ___ / ___

___ / ___ / ___

EXTRA

WEEK 34

___/___/___

___/___/___

___/___/___

___/___/___

___/___/___

EXTRA

WEEK 35

___ / ___ / ___

___ / ___ / ___

___ / ___ / ___

___ / ___ / ___

___ / ___ / ___

EXTRA

WEEK 36

___ /___ /___

___ /___ /___

___ / ___ / ___

___ / ___ / ___

___ / ___ / ___

___ / ___ / ___

___ / ___ / ___

EXTRA

A WEEK OF FOOD

You taste, eat, and drink dozens of things daily,
which makes food and beverages an easy place
to begin capturing the colors and sentiments
of each day. Sometimes the color of something
I drank will be so beautiful or vibrant that I can
simply attempt to mix and paint that color in my
sketchbook. Other times, the act of sharing a meal
or tasting a new food can be worth recording
and you can invent or assign a color to these
moments. If food inspires you for more than a
week, allow yourself to expand your colors and
thoughts beyond literal food items into more
experiential food-related moments.

Sherbet flavored

watermelon running
down sticky skin

tuesday cocktail

we drank rosé and
everything was backlit

iced chai + catching
up

orange-flavored
things

honey at the bottom
of the cup

table for two at my
fav italian

WEEK 37

___ /___ /___

___ /___ /___

___ / ___ / ___

___ / ___ / ___

___ / ___ / ___

___ / ___ / ___

___ / ___ / ___

EXTRA

WEEK 38

___ / ___ / ___

___ / ___ / ___

___ / ___ / ___

___ / ___ / ___

___ / ___ / ___

___ / ___ / ___

___ / ___ / ___

EXTRA

WEEK 39

___ /___ /___

___ /___ /___

___ / ___ / ___

___ / ___ / ___

___ / ___ / ___

___ / ___ / ___

___ / ___ / ___

EXTRA

___ / ___ / ___

___ / ___ / ___

___ / ___ / ___

___ / ___ / ___

___ / ___ / ___

___ / ___ / ___

___ / ___ / ___

EXTRA

A WEEK OF PLACES

Using a place as a jumping off point, focus on the colors, light, and overall feeling of your environment. This spread was especially fun when I was on a weeklong vacation at Lake Tahoe, where I had time to capture everything from the color of the pebbles on the shoreline to the effect of twilight on the water. You don't need to go far to do this exercise. You might focus on the items in one room in your house, or the colors that you see on your daily commute, or observations from a single vantage point, like the kitchen window or a bench in the park.

lichen on trees

pebbles smoothed over time

fallen pine needles

fresh spruce

3 feet deep

cabin in
the woods

beach blanket

the lake at twilight

WEEK 41

___ / ___ / ___

___ / ___ / ___

___ / ___ / ___

___ / ___ / ___

___ / ___ / ___

EXTRA

WEEK 42

___ / ___ / ___

___ / ___ / ___

___ / ___ / ___

___ / ___ / ___

___ / ___ / ___

___ / ___ / ___

___ / ___ / ___

EXTRA

WEEK 43

___ /___ /___

___ /___ /___

___ / ___ / ___

___ / ___ / ___

___ / ___ / ___

___ / ___ / ___

___ / ___ / ___

EXTRA

___ / ___ / ___

___ / ___ / ___

___ / ___ / ___

___ / ___ / ___

___ / ___ / ___

___ / ___ / ___

___ / ___ / ___

EXTRA

A WEEK OF WORDS

Choosing your color often begins by selecting a word first (a place, a person, an emotion). Why not lean into this part of the process by picking words that jump out at you and then painting a color that comes to mind when you repeat that word to yourself? I distinctly remember being about twelve and marveling over the word *carrot* (don't ask me why). At this moment, I'm captivated by the words *surrender*, *plunge*, and *folie*. Take a week to focus on the musicality and poetry of language, and maybe research the origin of a word if you need further inspiration for your color.

chase

fragile

listening

altruistic

leather

malign

belonging

specimen

WEEK 45

___ /___ /___

___ /___ /___

___ / ___ / ___

___ / ___ / ___

___ / ___ / ___

___ / ___ / ___

___ / ___ / ___

EXTRA

WEEK 46

___ / ___ / ___

___ / ___ / ___

___ / ___ / ___

___ / ___ / ___

___ / ___ / ___

___ / ___ / ___

___ / ___ / ___

EXTRA

WEEK 47

___ / ___ / ___

___ / ___ / ___

___ / ___ / ___

___ / ___ / ___

___ / ___ / ___

EXTRA

WEEK 48

___ / ___ / ___

___ / ___ / ___

___ / ___ / ___

___ / ___ / ___

___ / ___ / ___

___ / ___ / ___

___ / ___ / ___

EXTRA

A WEEK OF SPONTANEITY

Allow yourself to be open to chance and serendipity this week. This is a great way to counterbalance the taxing decision-making that we do every day. Try flipping open a book and selecting a word at random to serve as the inspiration for your color. Or close your eyes, wave your brush over your palette, and use whichever color your brush is pointing to (regardless of whether you like that color). Ask a friend to pick a color or word for you. Experiment, and release yourself from expectations. If you don't like the results one day, remember that there is always tomorrow.

the scent of plums

Smolder

reflections

unexplored
corners

new dress

mango lassi

open mouth

found in
nature

WEEK 49

___ /___ /___

___ /___ /___

___ / ___ / ___

___ / ___ / ___

___ / ___ / ___

___ / ___ / ___

___ / ___ / ___

EXTRA

WEEK 50

___ / ___ / ___

___ / ___ / ___

___ / ___ / ___

___ / ___ / ___

___ / ___ / ___

___ / ___ / ___

___ / ___ / ___

EXTRA

WEEK 51

___ /___ /___

___ /___ /___

___ / ___ / ___

___ / ___ / ___

___ / ___ / ___

___ / ___ / ___

___ / ___ / ___

EXTRA

WEEK 52

___ /___ /___

___ /___ /___

___ / ___ / ___

___ / ___ / ___

___ / ___ / ___

___ / ___ / ___

___ / ___ / ___

EXTRA

Editor: Karrie Witkin
Designer: Darilyn Lowe Carnes
Production Manager: Rebecca Westall

ISBN: 978-1-4197-4747-2

Text and illustrations © 2020 Courtney Cerruti

Cover © 2020 Abrams

Published in 2020 by Abrams Noterie, an imprint of ABRAMS. All rights
reserved. No portion of this book may be reproduced, stored in a
retrieval system, or transmitted in any form or by any means, mechanical,
electronic, photocopying, recording, or otherwise, without written
permission from the publisher.

Printed and bound in China
10 9 8 7 6 5 4 3

Abrams Noterie products are available at special discounts when
purchased in quantity for premiums and promotions as well as fundraising
or educational use. Special editions can also be created to specification.
For details, contact specialsales@abramsbooks.com or the address below.

Abrams Noterie® is a registered trademark of Harry N. Abrams, Inc.

ABRAMS The Art of Books
195 Broadway, New York, NY 10007
abramsbooks.com

for Luca and Joe,
it will take me a lifetime
to document the color of my love
and gratitude. xo